Snow White

By the Brothers Grimm
Freely Translated From the German by
Paul Heins
With illustrations by Trina Schart Hyman

An Atlantic Monthly Press Book
Little, Brown and Company
Boston Toronto

TRANSLATION COPYRIGHT © 1974 BY PAUL HEINS

ILLUSTRATIONS COPYRIGHT © 1974 BY TRINA SCHART HYMAN

A
FIRST EDITION T 11/74
HOR

ATLANTIC-LITTLE, BROWN BOOKS
ARE PUBLISHED BY
LITTLE, BROWN AND COMPANY
IN ASSOCIATION WITH
THE ATLANTIC MONTHLY PRESS

LIBRARY OF CONGRESS CATALOGING IN PUBLICATION DATA
Grimm, Jakob Ludwig Karl, 1785-1863.
 Snow White.
 "An Atlantic Monthly Press book."
 [1. Folklore. 2. Fairy tales] I. Grimm,
Wilhelm Karl, 1786-1859, joint author. II. Heins,
Paul, tr. III. Hyman, Trina Schart, illus.
IV. Title.
PZ8.G882Sn25 398.2'2'0943 73-13585
ISBN 0-316-35450-3

Published simultaneously in Canada by Little, Brown & Company (Canada) Limited

PRINTED IN THE UNITED STATES OF AMERICA

To Ethel L. Heins

For my Mother and Katrin and Dilys

TSH

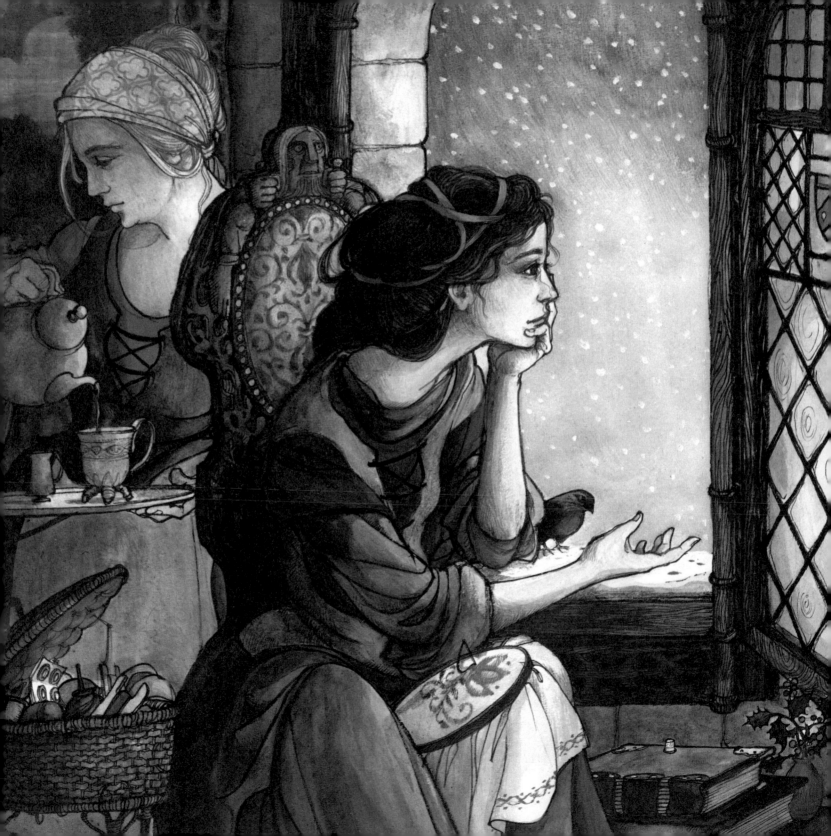

ONCE in the middle of winter, when snowflakes were falling like feathers from the sky, a Queen sat sewing by a window, and its frame was of black ebony. As she sewed, she glanced up at the snow and stuck her finger with the needle and three drops of blood fell into the snow. Since the red seemed so beautiful against the white, she thought to herself, "If only I had a child as white as snow, as red as blood, and as dark as ebony."

Soon afterward, she gave birth to a little girl who was as white as snow and as red as blood, and whose hair was as black as ebony. She was named Snow White. And the very moment the child was born, the Queen died.

A year later, the King took another wife. She was beautiful, but proud and arrogant, and could not endure to be surpassed in beauty. She had a marvelous mirror, and she would stand before it and view herself, saying,

Mirror, mirror on the wall,
Who is most beautiful in the land?

And the mirror would answer,

Lady Queen, you are the most beautiful lady in this land.

Then she would be satisfied, for she knew that the mirror was telling the truth.

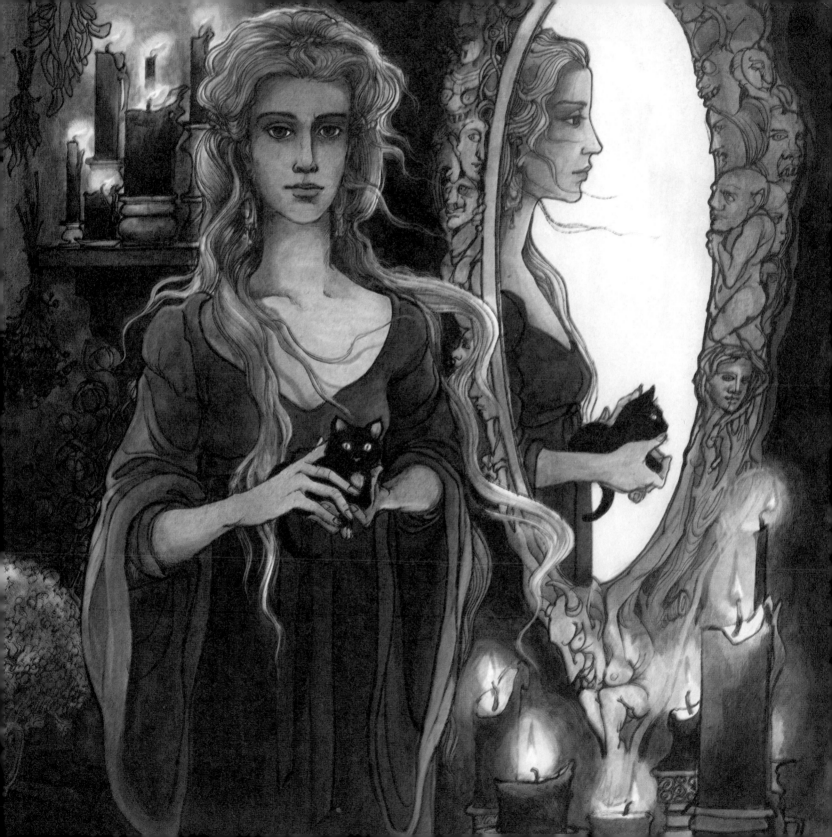

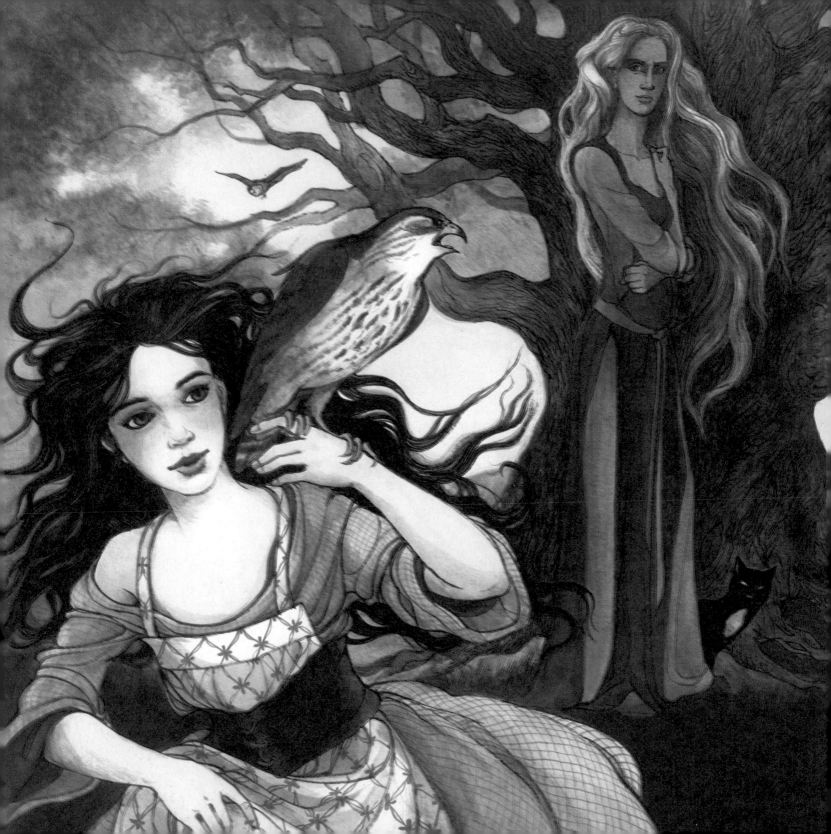

However, Snow White began to grow, and increased in beauty; and when she was seven years old, she was as beautiful as daylight and more beautiful than the Queen herself.

The time came when the Queen asked,

> Mirror, mirror on the wall,
> Who is most beautiful in the land?

and the mirror answered,

> Lady Queen, you are the most beautiful here,
> But Snow White is a thousand times more beautiful than you.

The Queen was horrified, and turned yellow and green with envy. From that hour on, whenever she looked at Snow White her heart sank, so deeply did she hate the girl. Envy and pride grew ever stronger, like weeds in the Queen's heart, and she could no longer rest, neither night nor day.

Finally, she summoned a hunter and said: "Take the child away into the forest. I never want to see her again. Kill her, and bring me her lungs and her liver as a sign of her death."

The hunter obeyed and led the girl away. When he drew out his hunting knife to pierce her heart, she began to cry and said: "O dear hunter, do not take my life. I will run away into the wild wood and never come back again." And since she was so beautiful, the hunter had pity on her and said, "Run away, you poor child." Wild animals will soon devour you, he thought.

It was as if a stone had been rolled away from his heart, since he could not bring himself to kill her. And when a young boar suddenly sprang into view, the hunter stabbed him, removed his lungs and liver, and brought them to the Queen. She had them salted and cooked, and the wicked woman ate them up, believing that she had eaten Snow White's liver and lungs.

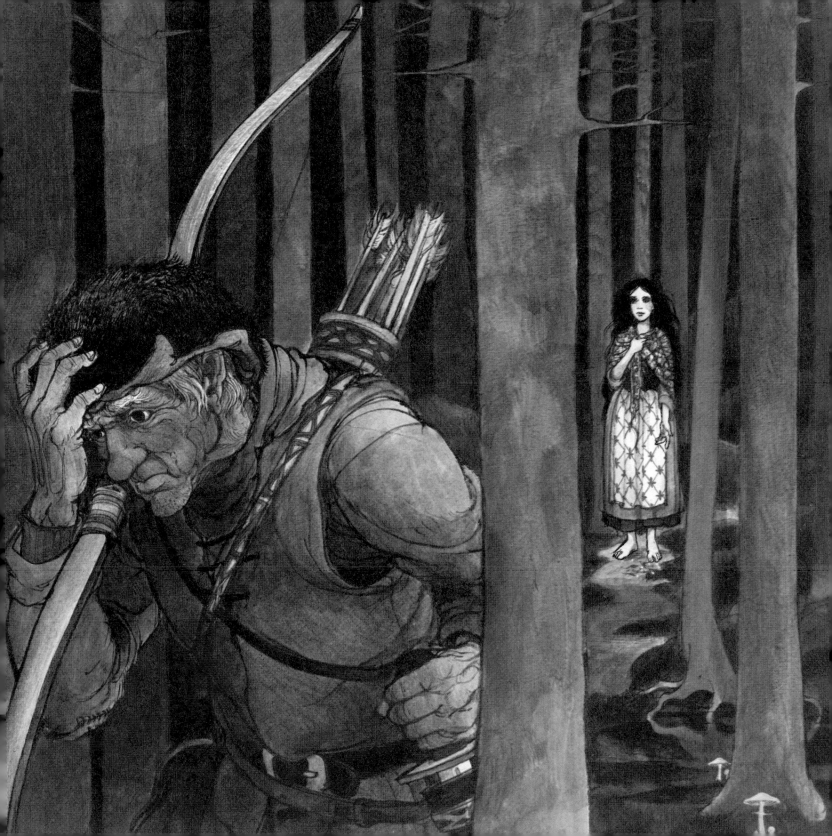

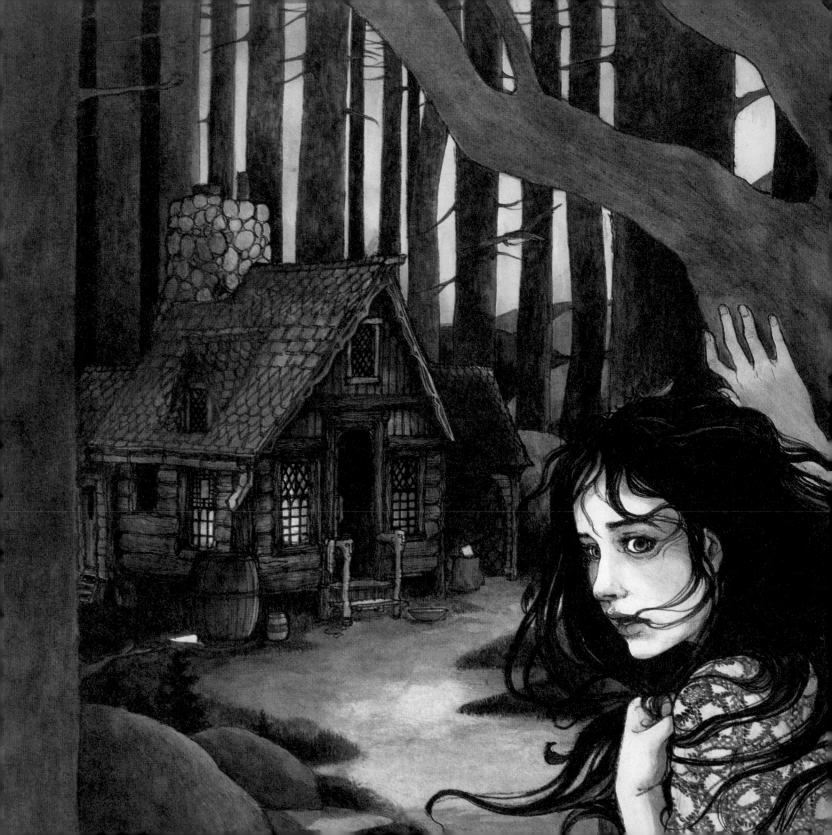

Now the poor child was completely alone in the great forest. She was frightened and did not know what to do. She began to run, and stumbled over sharp stones and into thorns. Wild animals sprang past her, but did her no harm. She ran as long as her legs could carry her until just before evening when she saw a little house and went inside to rest. In the house, everything was small, but neat and clean. There stood a little table, spread with a white cloth and laid with seven small plates, seven small spoons, seven little knives and forks, and seven little goblets. Against the wall were seven small beds placed in a row, and covered with white spreads. So hungry and thirsty was Snow White that she ate a bit of vegetable and a bit of bread from each plate, and drank a sip of wine from each goblet; for she did not want to take everything away from any one place. Afterward, since she was very tired, she tried lying down on one of the little beds, but none of them satisfied her—one was too long, another too short—until finally the seventh one seemed to be just right. There she stayed, said her prayers, and fell asleep.

When it was completely dark, the owners of the little house returned; they were seven dwarfs, who dug and hacked for gold in the mountains. They lighted their seven little candles, and saw that somebody had been there.

The first dwarf said, "Who has been sitting in my little chair?"

The second said, "Who has been eating from my little plate?"

The third said, "Who has taken some of my bread?"

The fourth said, "Who has been eating some of my vegetables?"

The fifth said, "Who has been using my little fork?"

The sixth said, "Who has been cutting with my little knife?"

The seventh said, "Who has been drinking from my little goblet?"

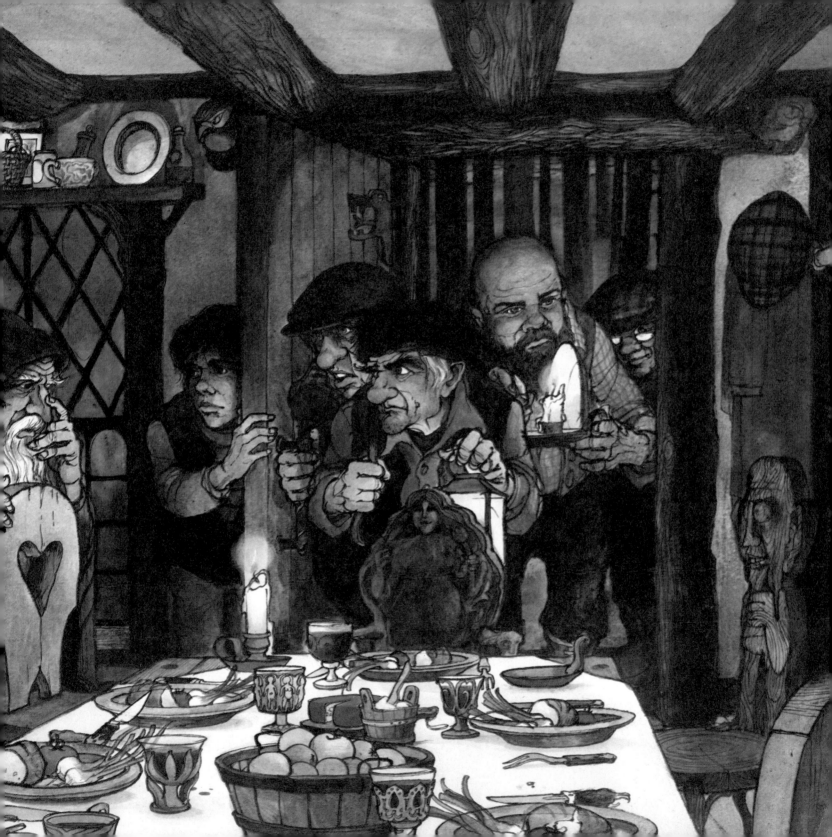

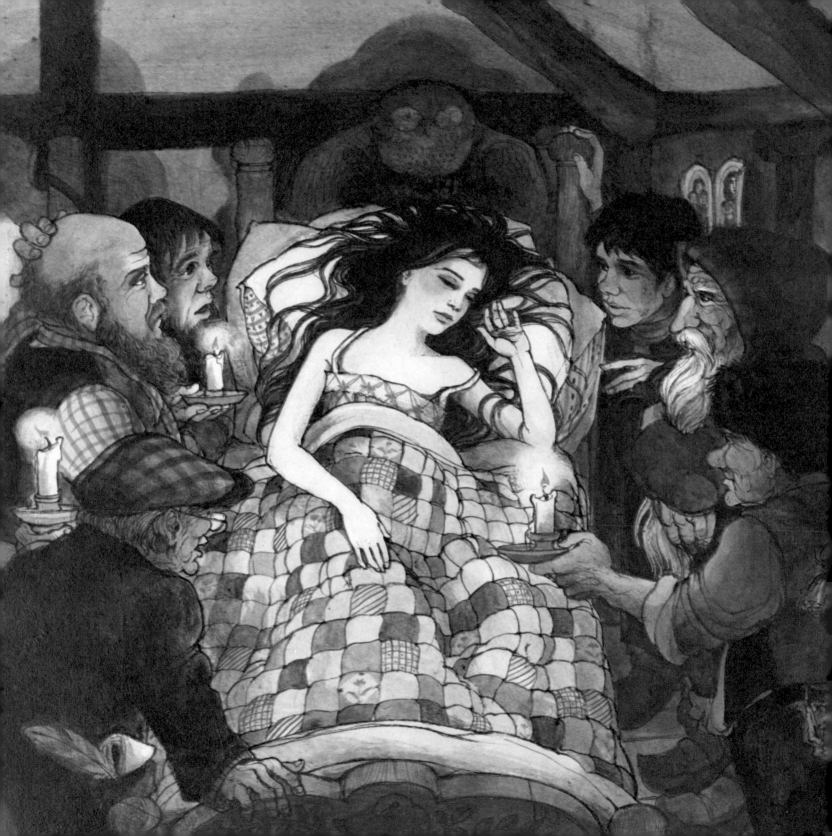

Then the first dwarf looked around and saw that there was a hollow place in his bed and said, "Who has been lying in my bed?"

The others came running and called out: "Somebody has also been lying in mine."

As the seventh one, however, looked at his bed, he saw Snow White in it—asleep. He called the others, and they came running and shouting with astonishment. They brought their seven little candles and light shone on the sleeping girl.

"How beautiful the child is," they cried out. Their joy was so great that they did not wake her, but let her continue to sleep in the little bed. The seventh dwarf slept with his companions, one hour with each, and so, in this way, the night went by.

In the morning, when Snow White awoke she saw the seven dwarfs and became frightened. But they were friendly and asked, "What is your name?"

"I am called Snow White," she answered.

"How did you come to our house?" continued the dwarfs.

Then she told them that her stepmother had wanted to kill her, but that the hunter had spared her life and that she had kept running the whole day until she found their little house.

The dwarfs said, "Would you like to take care of our house—cook, make our beds, wash our clothes, knit and sew? If you will keep everything neat and clean, you can remain with us, and you will not lack for anything."

"Yes," said Snow White, "with all my heart," and she remained with them.

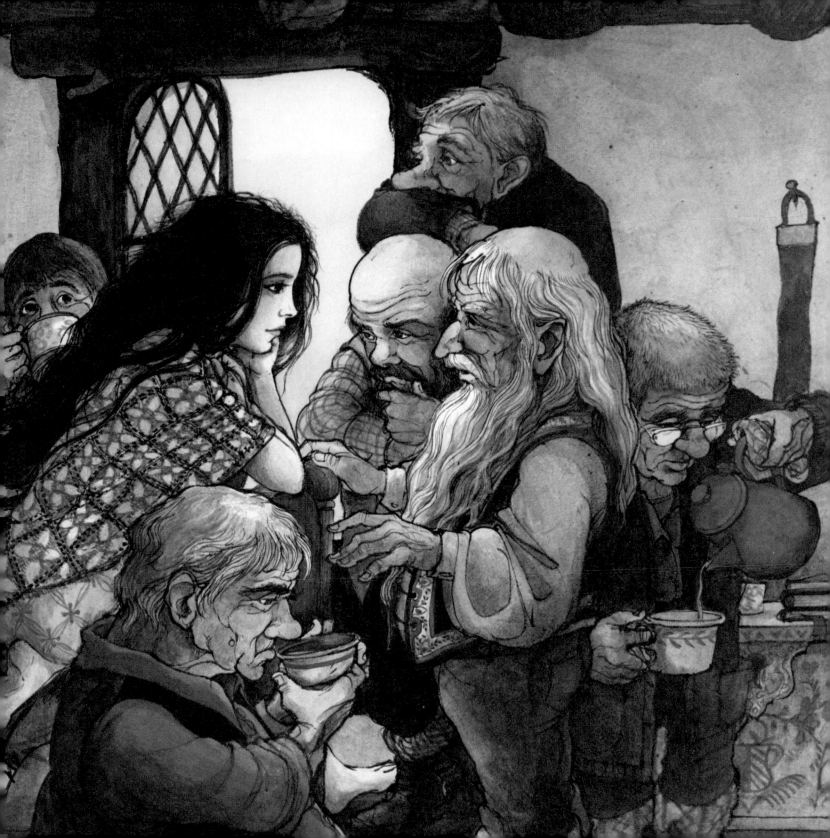

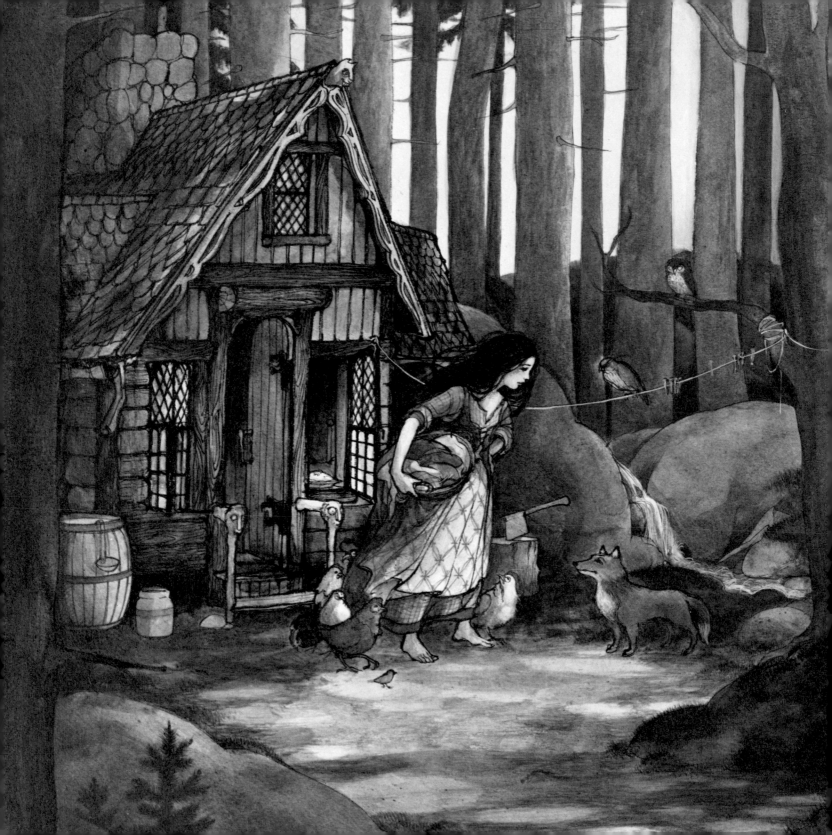

She kept the house in order. Every morning the dwarfs went to the mountains looking for gold and ore; every evening they came back and their food was ready. Throughout the day the girl remained alone, so the good dwarfs warned her and said, "Beware of your stepmother. She will soon learn that you are here. Let no one in."

The Queen, believing that she had eaten Snow White's lungs and liver, stepped before her mirror and said,

> Mirror, mirror on the wall,
> Who is most beautiful in the land?

Whereupon the mirror answered,

> Lady Queen, you are the most beautiful here,
> But Snow White beyond the mountains
> With the seven dwarfs
> Is still a thousand times more beautiful than you.

Whereupon she was terrified, for she knew that the mirror did not lie. She realized that the hunter had deceived her and that Snow White was still alive. And she thought again and again of how to destroy Snow White. For as long as the Queen was not the most beautiful in all the land, her jealousy gave her no rest. And when she finally thought of a scheme, she dyed her face and dressed herself like an old pedlar, and was quite unrecognizable.

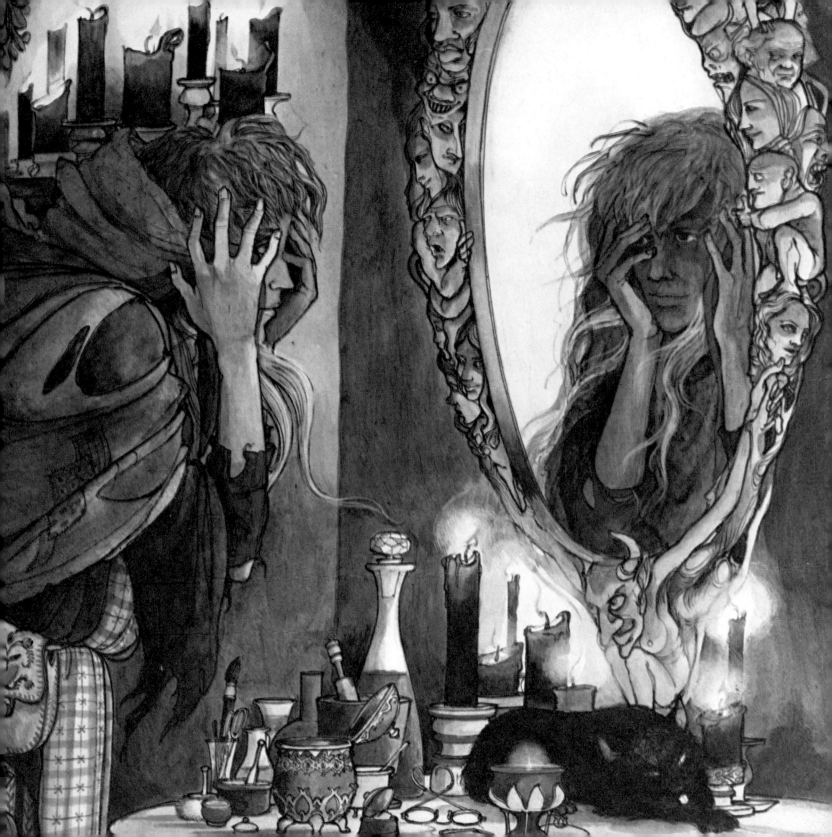

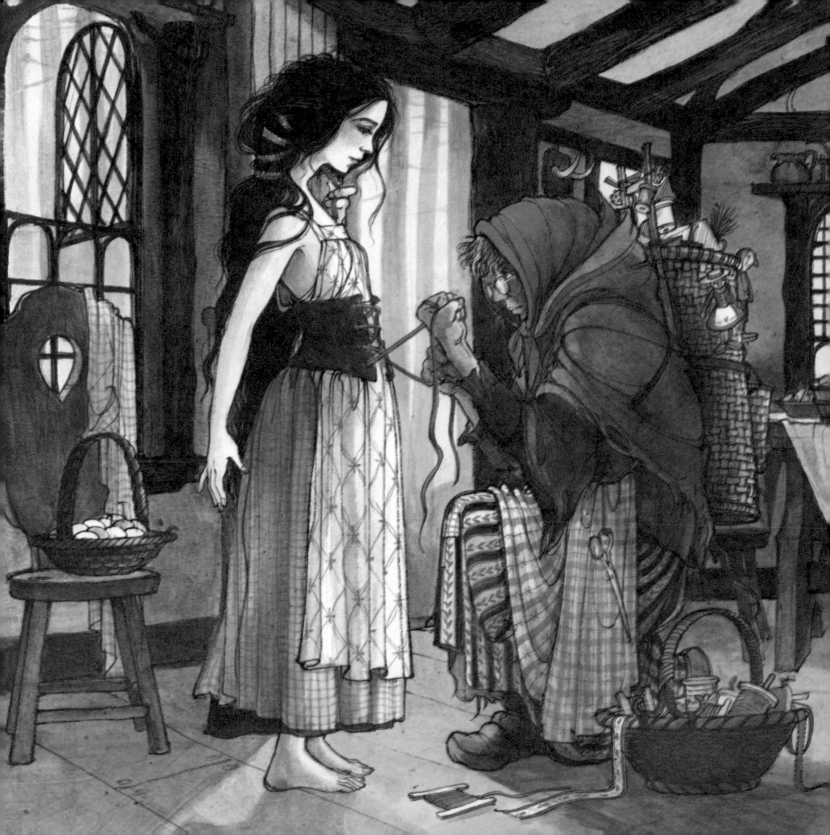

In this disguise she went over the seven mountains to the house of the seven dwarfs, knocked at the door, and called out: "Pretty things for sale, for sale."

Snow White looked out of the window and said: "Good day, dear woman. What are you selling?"

"Good things, pretty things," she answered. "Lacings of all colors," and she took one out that was made of bright silk.

"I can let this honest woman in," thought Snow White, who unbolted the door and bought the handsome lacings.

"Child," said the old woman, "what a sight you are! Come, I will lace you up properly—for once."

Snow White was not worried. She stood before the woman, and permitted herself to be laced up with the new ribbons; but the old woman tightened them so swiftly and so firmly that Snow White gasped and fell down as if dead.

"Now you are no longer the most beautiful," the Queen said, and hurried away.

Not long after, toward evening, the seven dwarfs came home, but how frightened they were when they saw their beloved Snow White lying on the ground. She neither stirred nor moved. It was as if she were dead. They lifted her up, and when they saw that she was too tightly laced, they cut the ribbons in two. Then she began to breathe a bit and after a while became more and more lively.

When the dwarfs heard what had happened, they said, "The old pedlar was none other than the evil Queen. Take care and let nobody in if we are not with you."

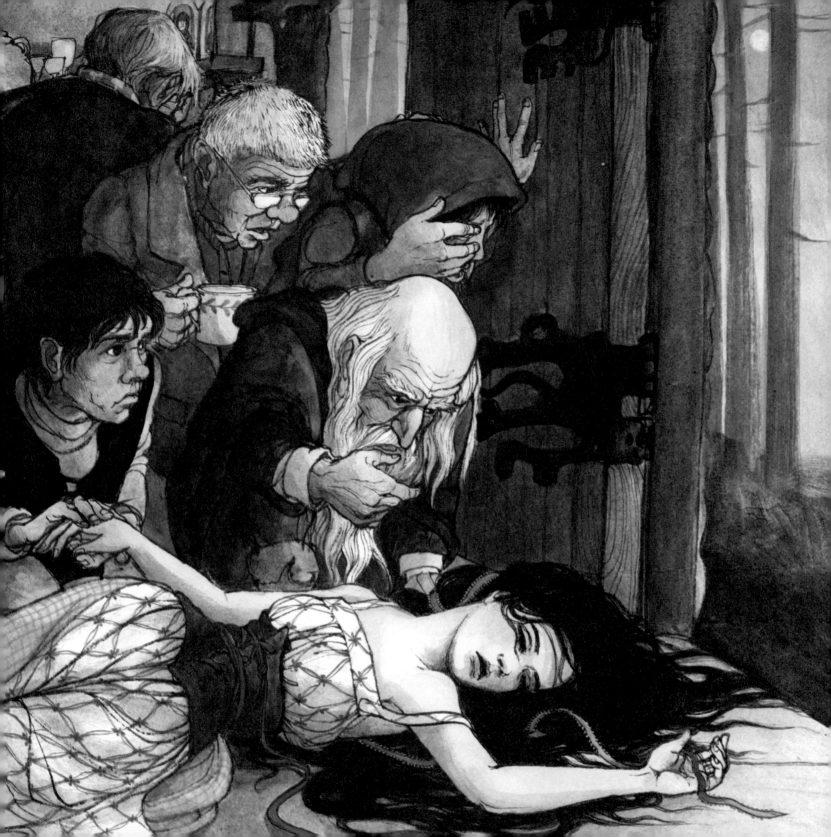

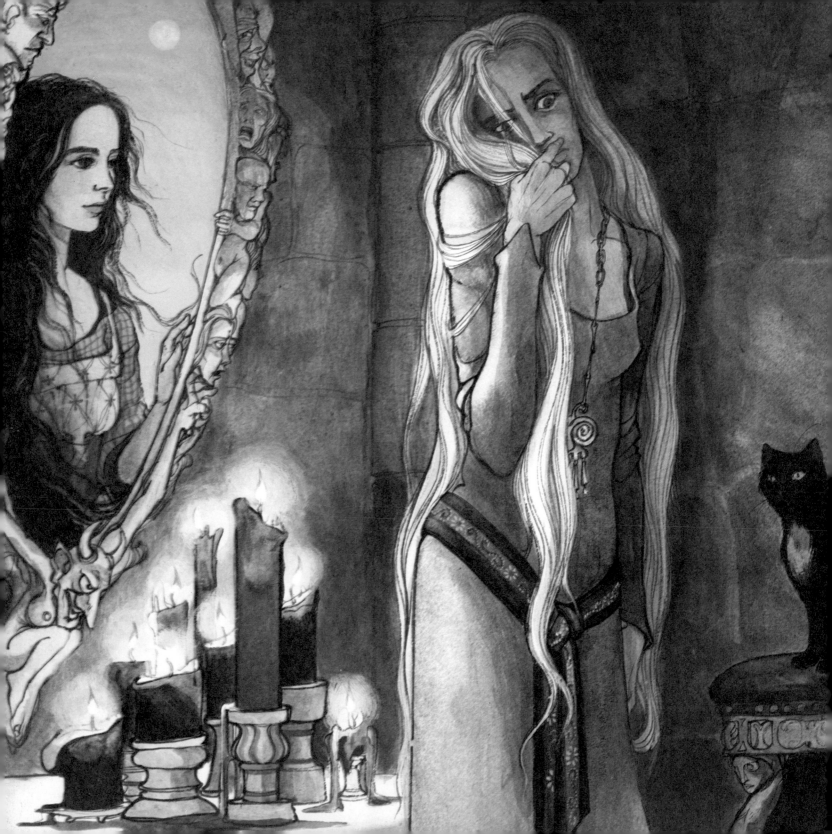

When the wicked woman arrived home, she went before the mirror and asked,

> *Mirror, mirror on the wall,*
> *Who is most beautiful in the land?*

It answered as before,

> *Lady Queen, you are the most beautiful here,*
> *But Snow White beyond the mountains*
> *With the seven dwarfs*
> *Is still a thousand times more beautiful than you.*

When she heard this, blood raced to her heart so terrified was she, for she realized that Snow White had been brought back to life.

"I will think of something," she said, "that will be your downfall," and by means of witchcraft, she made a poisoned comb. Then she disguised herself and again took on the appearance of an old woman.

And she went over the seven mountains to the house of the seven dwarfs, knocked at the door, and called out: "Good things for sale, for sale."

Snow White looked out and said, "Don't bother to stop. I mustn't let anybody in."

"Looking will do no harm," said the old woman. She took out the poisoned comb, and held it up high. The comb pleased the child so much that she permitted herself to be deceived again and opened the door.

When they had agreed upon the price, the old woman said, "Now I will comb your hair neatly—for once."

Poor Snow White saw nothing wrong and permitted the old woman to do so. But scarcely had the comb touched her hair than the poison worked and the girl fell down senseless.

"You paragon of beauty, now you have what you deserve," cried the wicked woman and went away. Luckily, however, it was soon evening, and the seven dwarfs came home. When they saw Snow White lying on the ground as if dead, they immediately suspected her stepmother, searched, and found the poisoned comb. Scarcely had they drawn it out than Snow White recovered and told them what had happened. Again they warned her to be careful and to open the door for nobody.

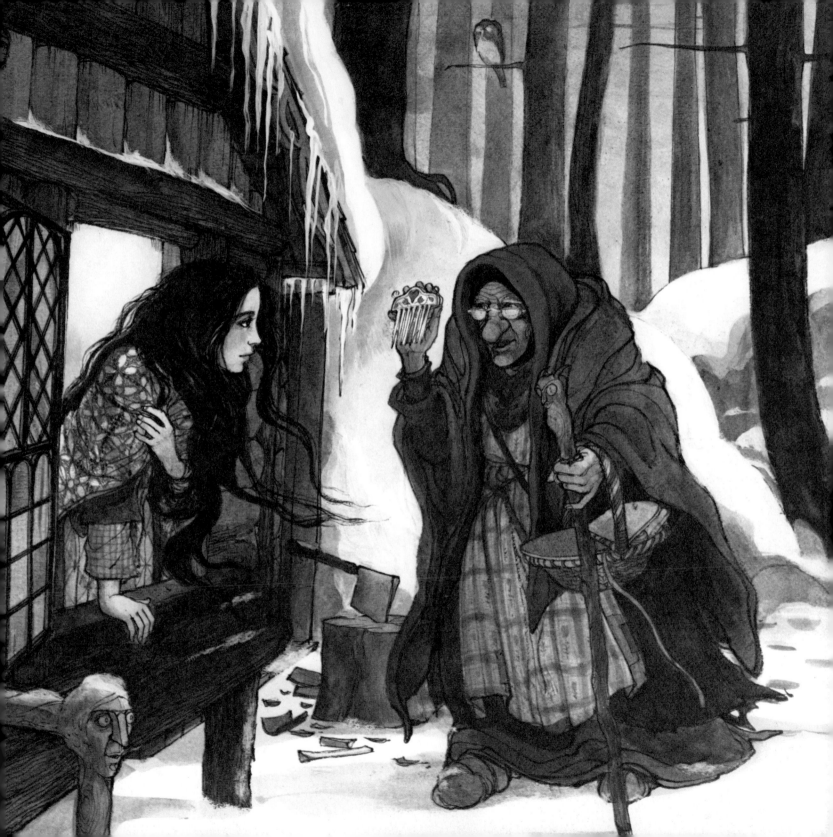

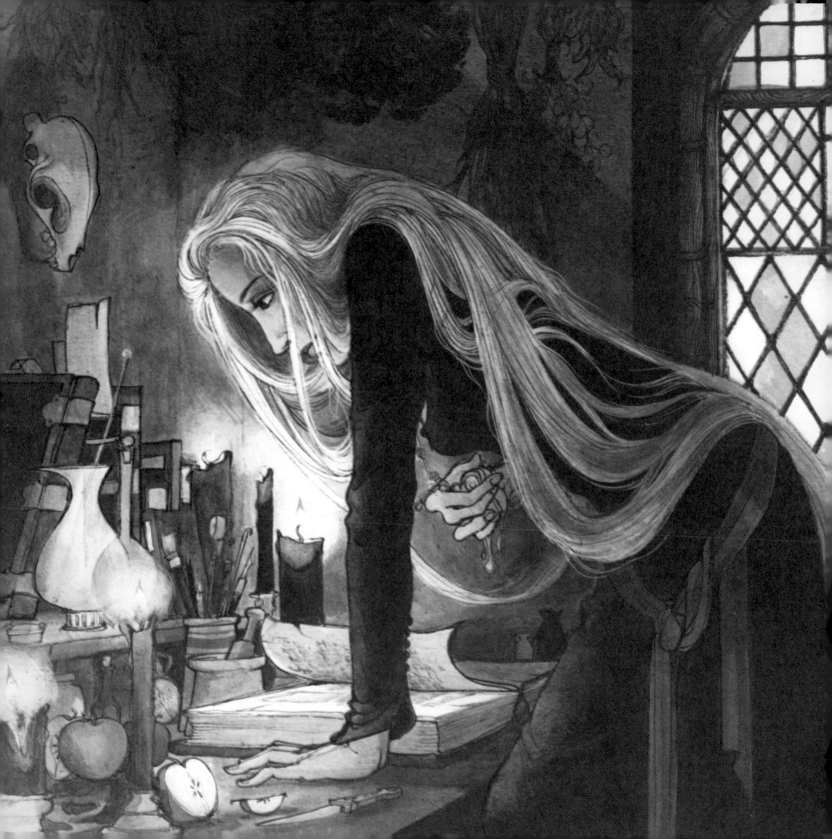

At home, the Queen stood before the mirror and said,

> *Mirror, mirror on the wall,*
> *Who is most beautiful in the land?*

And it answered as before,

> *Lady Queen, you are the most beautiful here,*
> *But Snow White beyond the mountains*
> *With the seven dwarfs*
> *Is still a thousand times more beautiful than you.*

As she heard the mirror say this, she trembled and shook with rage. "Snow White shall die," she cried out, "even if it costs me my own life."

Then she went into a hidden, deserted room and created a poisonous apple. On the surface it looked so beautiful—white and red—that whoever looked at it became possessed by a desire to eat it, but whoever ate a bit of it would die. When the apple was ready, the Queen dyed her face and dressed like a peasant woman. Again she went over the seven mountains to the house of the seven dwarfs.

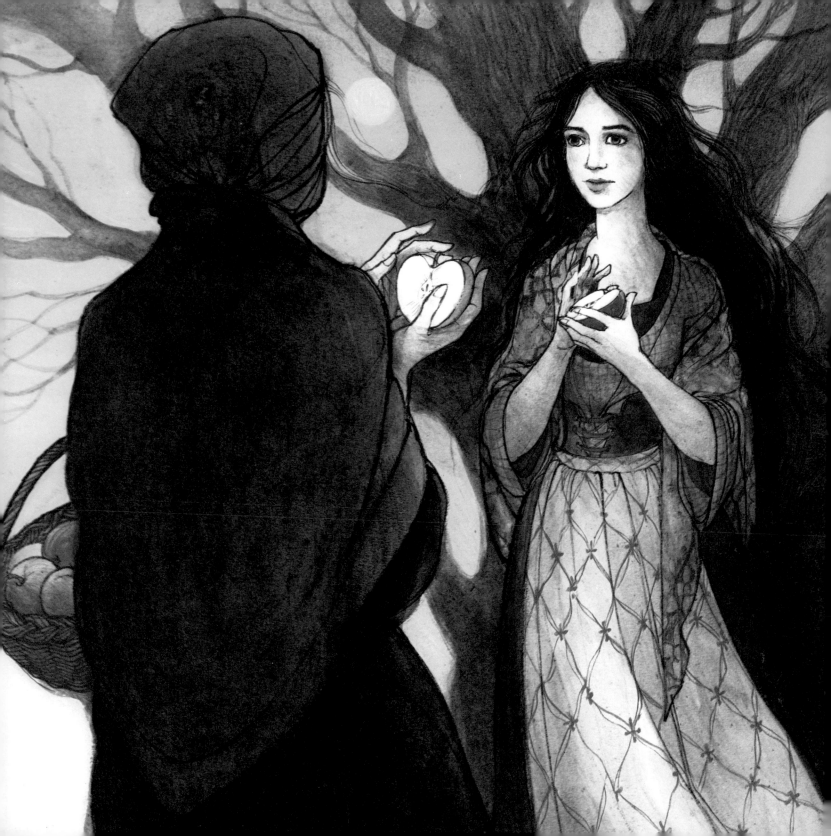

She knocked. Snow White put her head out of the window, and spoke, "I mustn't let anybody in; the seven dwarfs have forbidden me to do so."

"I don't have to come in," answered the peasant woman. "Look, I will give you one of my apples."

"No," answered Snow White, "I must not accept anything."

"Are you afraid of poison?" asked the old woman. "See, I am cutting the apple in two. You eat the red half and I will eat the white." The apple was so cleverly made that only the red half was poisonous.

Snow White hankered after the beautiful apple, and when she saw that the peasant woman had bitten into it, she could no longer resist. She stretched out her hand and took the poisoned half. No sooner did she have a bite of it in her mouth than she fell down dead.

The Queen gave her a hideous glance and laughed aloud and cried, "As white as snow, as red as blood, as black as ebony. This time the dwarfs will not be able to wake you up."

And when at home she asked her mirror,

> *Mirror, mirror on the wall,*
> *Who is most beautiful in the land?*

at last it answered her,

> *Lady Queeen, you are the most beautiful lady in the land.*

And her envious heart found rest.

That night when the dwarfs came home they found Snow White lying on the floor. No breath came from her mouth; she was dead. They picked her up, looked for something poisonous, unlaced her, combed her hair, washed her with water and wine, but nothing helped. The dear child was dead and remained dead.

They laid her on a bier, and all seven of them sat round it and wept for her for three days. Then they wanted to bury her, but she seemed fresh and alive, and still had beautiful red cheeks.

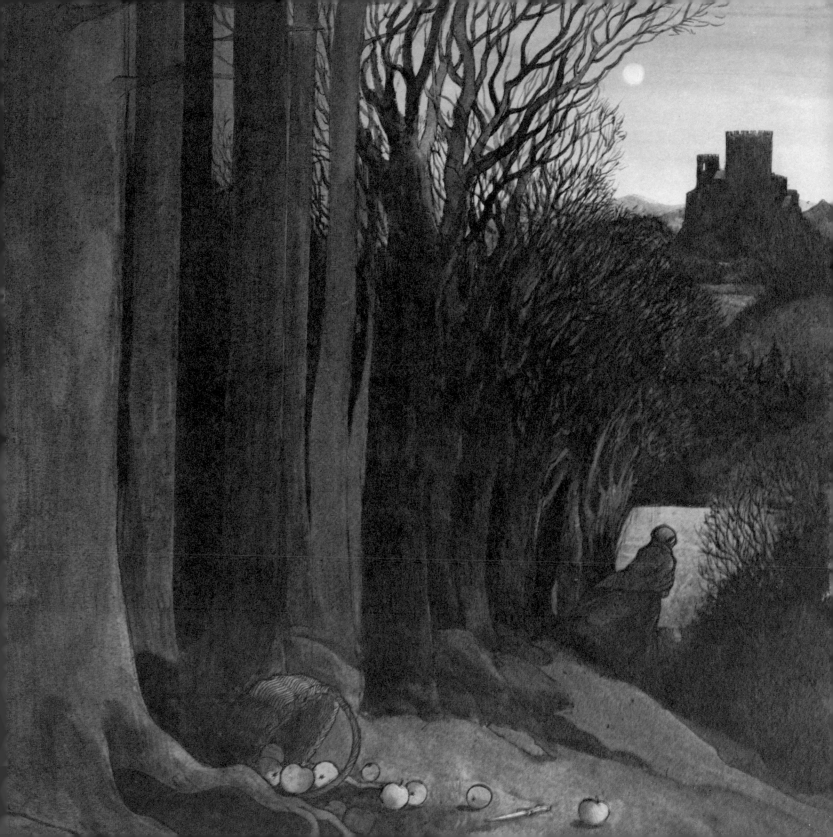

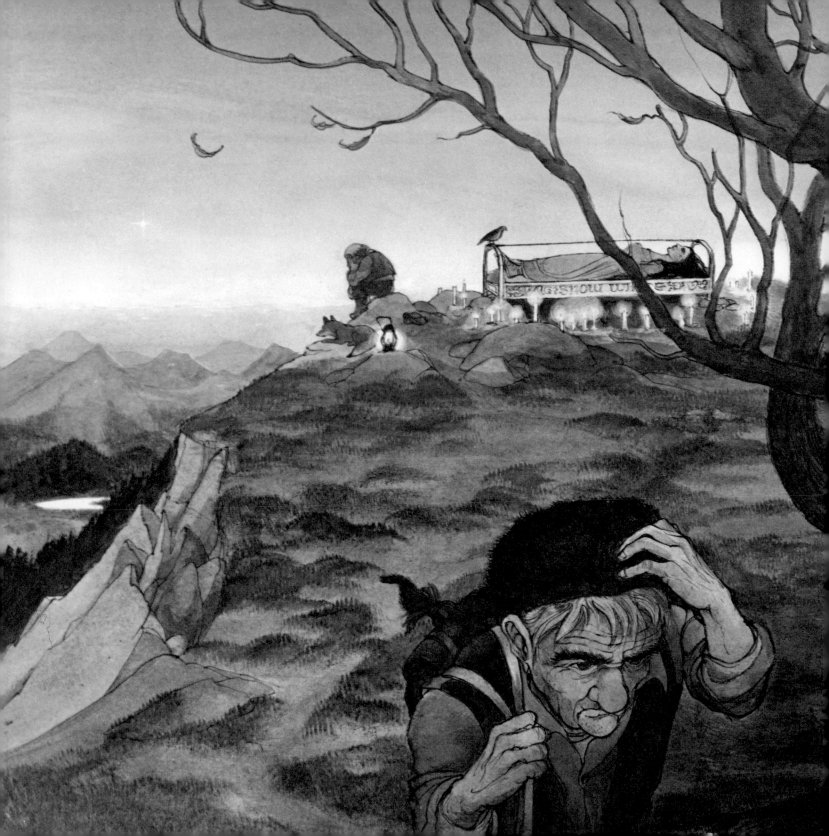

The dwarfs said, "We cannot bury her in the dark earth," and had a coffin made of glass so that she could be seen on all sides, laid her in it, and wrote her name in golden letters to show that she had been the daughter of a king. They set the coffin up on a mountain and took turns keeping watch. And creatures came and wept for Snow White—first an owl, then a raven, and finally a dove.

Snow White remained in the coffin a long, long time. She didn't decay, but seemed to be sleeping, for she was still as white as snow and as red as blood, and her hair was as black as ebony.

It happened that a king's son discovered the forest and came to spend a night in the house of the dwarfs. He saw the coffin on the mountain, and Snow White, and read what was written in golden letters.

He said to the dwarfs, "Give me the coffin. I will give you anything you want in return for it."

But the dwarfs answered, "We shall not give it up for all the gold in the world."

"Then," he said, "give it to me as a gift, for I cannot live without seeing Snow White. I will honor her and treasure her as my dearest." Since he spoke in this way, the dwarfs felt pity for him and gave him the coffin.

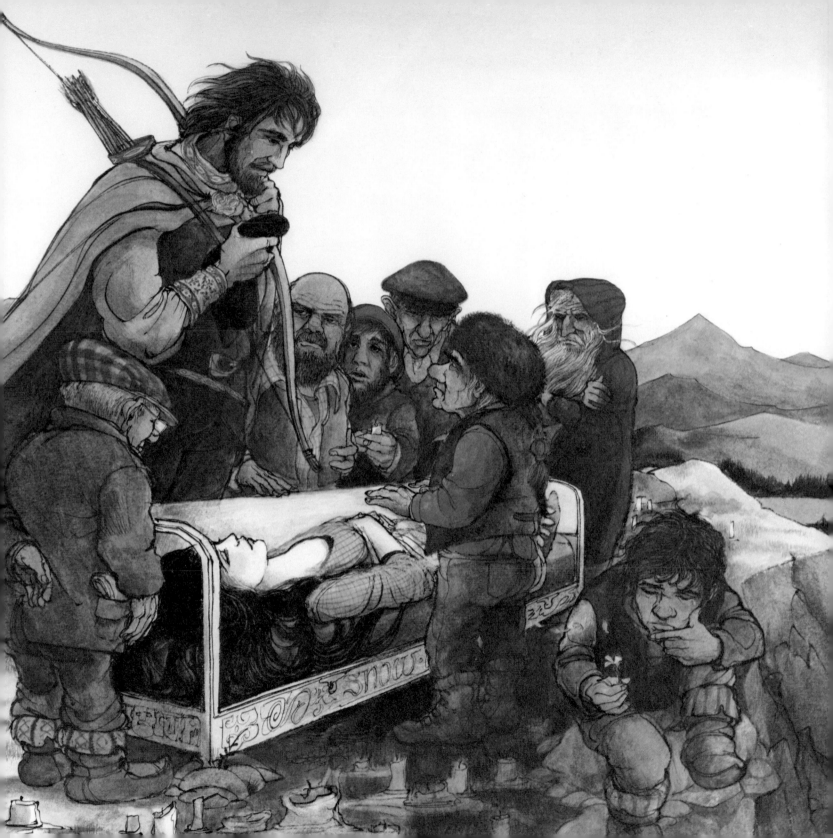

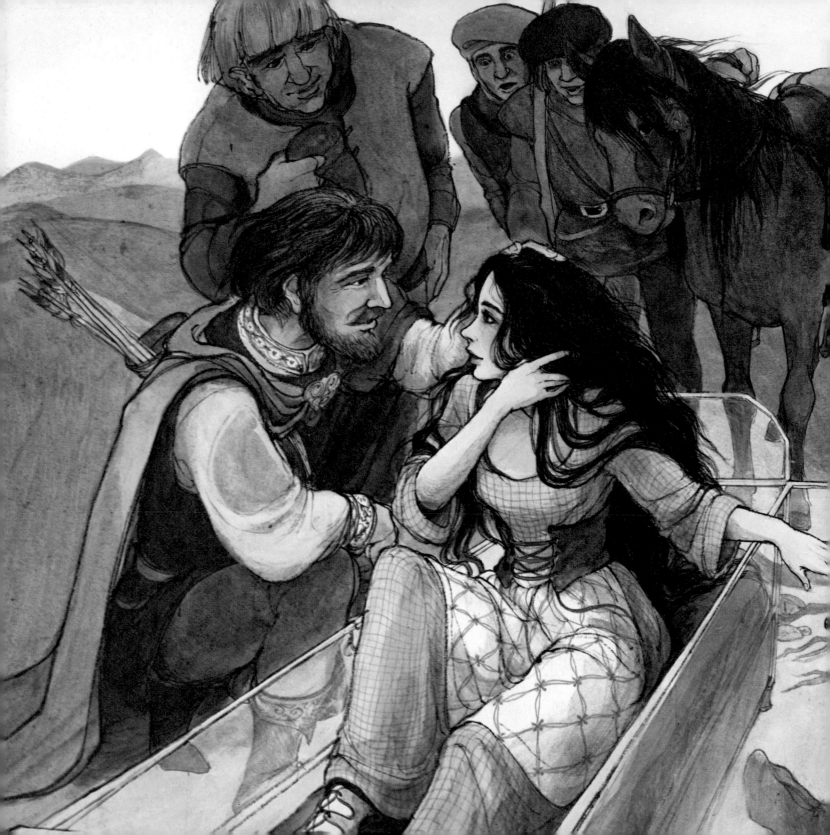

And the king's son had it carried forth on the shoulders of his servants. They happened to stumble over a bush, and because of the jolting, the piece of poisoned apple was dislodged from her throat. And not long after, she opened her eyes, raised the lid of the coffin, sat up, and was alive again.

"Where am I?" she called out.

The king's son said joyfully, "You are with me," and told her what had happened. "I love you more than anything in the world. Come with me to my father's castle, and you shall be my wife."

Snow White was happy to go with him. Their wedding was arranged with great splendor and magnificence and, among others, Snow White's evil stepmother was invited to the festivities. After she dressed herself in beautiful clothes, she stood before her mirror and said,

> Mirror, mirror on the wall,
> Who is most beautiful in the land?

The mirror answered,

> Lady Queen, you are the most beautiful here,
> But the young Queen is a thousand times more beautiful than you.

Then the wicked woman uttered a curse, and she was so miserable she did not know what to do. At first, she did not want to go to the wedding at all. But she could not rest; she had to see the young Queen.

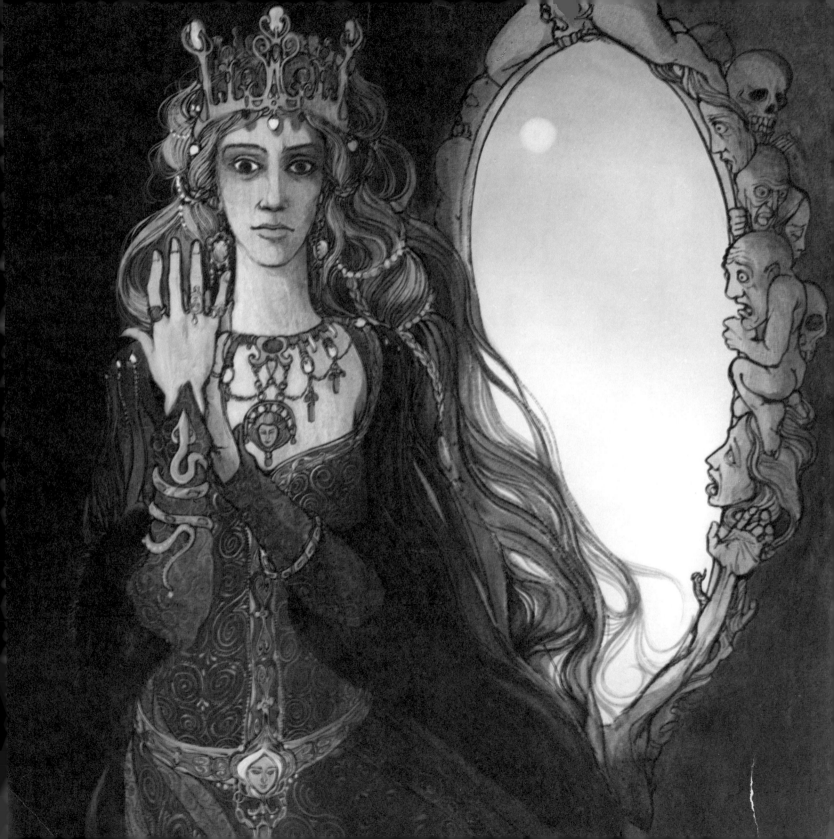

As soon as she arrived, she recognized Snow White and stood there—full of anguish and terror—and could not move. But iron slippers had already been placed on a coal fire and were brought in with tongs and placed before her. She had to step into the red hot shoes and dance until she fell down dead.